MW00533109

Sixty Tattoos I Secretly Gave Myself at Work

Published by Trident Press
940 Pearl St.
Boulder, CO 80302

ISBN: 978-0-9992499-5-6

Cover and author photos by Jillian Mann
Edited by Nathaniel Kennon Perkins

Sixty Tattoos I Secretly Gave Myself at Work

By Tanner Ballengee

Trident Press
Boulder, CO

For Mia and Theron,
For providing me with the
mediocre and middle class
childhood for which I cannot
thank them enough.

SIXTY TATTOOS I SECRETLY GAVE MYSELF AT WORK

Yes, you read that right. And no, I didn't work at a tattoo shop.

My place of employment is a little hard to explain. I used to hate having to answer the "what do you do?" question at bars and social gatherings. Occasionally, when I was feeling lazy and didn't want to get into it, I'd just say I worked at a call center (which is what it would look like to someone who didn't work there). In actuality it wasn't that at all—yes, it was a job where I wore a goofy headset and had incoming calls, and I *did* talk, but I never spoke to anyone directly. Shit, this is starting to sound like a riddle.

I worked for a company, which I don't think I can legally name here, that makes home phones specially designed for deaf and

hard-of-hearing people. The phones have large built-in screens that write out, word for word, everything the person on the other end of the line says. That way, if the person using the phone can't hear or misses any part of the conversation, they can simply read what the other person said instead. The majority of the clientele were elderly citizens who weren't born deaf but slowly lost their hearing over time.

The phone and the service provided (sometimes referred to as a "relay service" or "TTY") are actually helpful and important tools that can really impact a person's life in a great way. For that reason I did feel some pride in my work, like I was actually making disadvantaged people's lives easier and better.

Like I said, a big percentage of the people who have these phones are old folks, and I'd say about 90% of them believe it's a computer transcribing the words of the person with whom they're talking. This is an understandable assumption, but they're wrong. There's actually a silent third party involved—a real live human being that's neither seen nor heard, listening to one side of

their private conversation, and dictating and/
or transcribing verbatim what the non-deaf
person is saying. I was one of those
real live human beings.

By "transcribing" I mean typing out by
hand, which we rarely did. By "dictating" I
mean repeating what we hear out loud word
for word. The hard-of-hearing people can't
hear the communication assistants. They can
only see the words we were relay. The employ-
ees sit in cubicles with computers, talking to
themselves aloud in monotone un-emphatic
voices all day long. As you could probably as-
sume, this process—while somewhat enter-
taining because of it's voyeuristic presence in
the lives of complete strangers—can become
incredibly mind-numbingly boring with a
slight chance of miserable. And that's what I
did, day after day, eight hours a day, for over
three years.

For my first month or so of working
there I showed up empty-handed except for
my water bottle and did my job until it was
time to clock out. Before long, I started to
feel like I was going to lose my fucking mind
if I didn't have something to spark at least a

tiny bit of stimulation and help me disengage from the mindless utter monotony of having to repeat other people's mundane conversations for hours everyday. The majority of new hires would call it quits after a couple months, which is probably what I should've done. The pay wasn't worth it at a measly $11 an hour (one dollar above Arizona's minimum wage!) with no chance of a raise unless you advanced to supervisor. The benefits were decent though, which might've been my sole reason for sticking with it. But in order to survive that daily grind I had to find something to keep my mind occupied. Like they say, "If you don't use it, you lose it."

Even though I didn't really like my job too well, I got pretty damn good at it. After a few months it became second nature, and I didn't have to constantly monitor my screen to see if my words were being dictated correctly (Although I do recall one specific time where I slipped up and let a person who'd ended a call with "You bet" come out as "You bitch" before I could correct it. That was fucked up, but instances like that were rare. Luckily my manager was remote-monitoring my screen).

So I started bringing books and reading on the clock. Then that got boring, so I brought notebooks and manuscripts I'd been working on and started writing. I started bending the rules a lot and doing more than I was allowed. They gave me an inch and I took a mile. Management started catching on when I began bringing my punk vests and patches to my cubicle. I'd sit and sew for my entire shift. This activity completely consumed my mind and entire day to the point that by the time I was finally finishing up sewing that big back patch on my jacket with dental floss, it was time to clock out. But it didn't last long. A company-wide email was sent out banning any and all sewing and/or knitting while taking calls. They were singling me out. I knew it.

I still sewed though from time to time. They couldn't stop me. I was still doing my job better than half the ASU freshman that worked with me. I was just trying not to go fucking crazy. I also did watercolor paintings, created magazine and newspaper collages, read like 50 books, wrote nearly two memoirs, put together at least ten zines, did my

taxes every April, filled up numerous sketch-books and journals with writings and draw-ings...all on the company's dime.

Oh yeah, I also gave myself *60 or so stick 'n' poke tattoos.*

I can't remember exactly when it start-ed, but I'd guess that during the last year and a half of my career there I was regularly tattooing myself in my cubicle. I started off experimenting at home; using tattoo needles that were lying around going unused after our house tattoo machine finally kicked the bucket. I was used to doing pokes with sew-ing needles, so I found that using actual tat-too needles made a world of difference.

After getting an abnormally substantial tax return after the year I turned 25 (which coincidentally is also the last year I had my dad do my taxes—I still don't know what the fuck he did to get me such a big return, but I wish he'd clue me in or somethin'), I decid-ed that 2015 was going to be the year I go H.A.M. on tattoos and finally finish my left arm sleeve that I'd been wanting since I was a teen. I had a buddy that worked in a respect-

able tattoo shop in Gilbert, AZ and did good work for good prices. I was in there once a month. Getting tattooed became addicting, like everyone says. The tiny blank spaces between bigger tattoos started bothering me. I had to have everything filled! Wrist to shoulder! So I started fucking around with small stick and pokes for a couple hours after work some days. The more poking I did, the more addicting *that* became. Then, one fateful evening after work, the proverbial light bulb appeared above my head and I thought, "Damn, I could probably do this at work tomorrow."

So I did. Cautiously at first, being very aware of my surroundings, constantly looking over my shoulder. *Would I get caught? Would anyone see me?* I thought hard about it. I worked in an office building full of cubicles. Sure, people walked through the cube aisles from time to time, but how often would they look my way? How often would it be a supervisor? And would they be able to tell what I was doing? I wasn't sure if this was a recipe for disaster or the perfect crime.

Turns out it was the latter. Slowly but surely I began giving myself tattoos. Small at

first. In my backpack I'd carry a small metal box with all my supplies: fresh needles, a bottle of India ink, a small bottle of green soap, deodorant (for the transfer paper), paper towels, pens, etc. I'd pull the box out (usually later in the day when less people were working) and set myself up in a way where I could quickly hide the needle if I need to. That way if someone stopped and questioned what I was doing I could say that I was simply drawing on myself with an old-fashioned ink pen like a bored seventh grader or something.

But no one ever asked. Literally not one person in the 18 or so months that I was tattooing myself in my cubicle. *Not one person!* There were times where I'd be completely bent over with my knee to my face, or my legs up on the desk with my pants rolled as high as they would go, and no one ever said a goddamn word! Were they all completely oblivious? Or did no one actually give a fuck?!

Whatever it was, I didn't care as long as no one put a stop to it. I found that giving myself stick and poke tattoos on the clock was the god-mode of ways to make the hours at work fly by like minutes. Better than read-

ing, writing, and sewing punk patches combined. Plus, I was fueling my addiction for new tattoos! In the wise words of Lil' Wayne: "Ink my whole body / I don't give a motherfuck."

When I tell someone that I did almost all of the tattoos on my legs myself, *while I was at work*, they usually react with a fair amount of surprise/shock. But I was so numb to it all that sometimes I'd forget that what I was doing was actually pretty fucking ridiculous. Not to mention the fact that I was getting away with it without anyone knowing or suspecting a thing. Hence this piece of literature you're holding.

 Of course, I wanted to tell this absurd story. But more than anything I wanted to tell the absurd stories behind this absurd story. Keep in mind, I'm not one of those self-righteous dorks that looks down their nose at you and says, "All of my tattoos have meanings behind them." Fuck that. Half of my tattoos may have some kind of valuable meaning or purpose symbolized in them, and the other half I just did for the fuckin' hell

 of it. I got a butt in the shape of a heart because I love butts. I got a grim reaper because I like *Bill & Ted's Bogus Journey* better than *Bill & Ted's Excellent Adventure*. I got a Middle Finger because...fuck you, that's why!

 I'll leave it at that. This collection of short vignettes is about some of the ones that mean more than others.

In the summer of 1982, my father took my mother out to the movie theater to see *Fast Times at Ridgemont High*. That was their first date. Seven years later they had their first child—a chubby baby boy with blonde hair. That little fella was me.

So in theory—hear me out—*Fast Times* played a minute but important role in what would eventually lead to my existence. How about that? What if my dad had taken her to see *Tron* or *The Dark Crystal* instead? Would that

have botched my chance at life? Would I slowly watch myself disappear from a family photograph like Marty McFly just before bursting into his celebratory "Johnny B. Goode" performance?

It's probably best not to think about it.

My dad doesn't have any tattoos. He once told me that if he had ever gotten one, it would've been me and my brother's names, if anything. My mom has two tattoos: one on her ankle and one on the top of her foot. I remember when she got the first one. It was a few years after my parents divorced. She'd just gotten remarried and was wilin' out—dying her hair, wearing thongs, drinking a lot. She even got her fuckin' belly button pierced. And somewhere along the line she got her first tattoo. It was a parrot above her ankle—but only the top half of the bird. Just the parrot's head.

My parents, although divorced, still shared a love for one particular musician: Jimmy Buffett. In case you don't know anything about him or his music, Buffett's hardcore fans refer to themselves as "Parrot Heads."

My dad still has these words in his email address. Personally, I like Jimmy Buffett just about as much as I like taking tequila shots with salt and lime—not at all. This probably stems from being forced to listen to every one of his CDs any time I was in the car with either parent. Around the time she got the tattoo, I remember my mom sitting in a white plastic lawn chair in our side yard out in rural Kansas, telling me she would sign for me to get a tattoo if I wanted one. I was maybe ten

years old. She was maybe eight Busch Lights deep.

Thank god that never happened. I probably would've gotten a character from *Dragon Ball Z*.

The Thick Chick tattoo on my right knee is based off old sailor flash I found in a book entitled *Vintage Tattoos – The Book of Old-School Skin Art* by Carol Clerk (page 118, "Pin-up girls...by Trevor Hodge.") I traced

the top half of the original drawing, stopping just past the butt. Then I redrew her with a more modern hair-do (straight-across bangs), armpit hair, and a more realistic body (bigger tummy/thighs and rounder, less perky breasts).

The other naked lady, on my calf, came from that same book (page 118, "Topless Hawaiian pin-up girls from Les Skuse, 1950s"). The only alteration I made was adding pubic hair. I left the banner blank because I couldn't think of anything clever or witty to poke on it. So I posted the finished photo of it to Instagram with the caption "Any suggestions?" A year later and the banner is still blank. The only suggestion I slightly considered doing was "MOM."

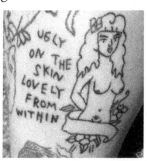

(I tattooed Ugly On The Skin the same day. It took my entire eight-hour shift to finish both. If you didn't know, this is one of the many shitty tattoos on that Ninja guy from Die Antwoord—on the topside of his right wrist. I used to admire how he rocked his poorly done tattoos with pride. I imagine that I got the idea to poke it on myself after seeing a photo of it on Tumblr. I probably thought it was "deep." I can't think of a better reason.)

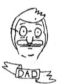

And clearly this isn't my dad. It's Bob Belcher from the TV show *Bob's Burgers*. But Bob and my dad do somewhat resemble each other with the bald spot and huge gut. Just change Bob's hair from black to light brown and add some on his chin to go with his mustache (turning it into a *van dyke*, not a *goatee*! That was made very clear to me at a young age), and you have an animated version of my father.

Another love my parents shared after their own deteriorated was for *Seinfeld*. And it's fairly obvious why. *Seinfeld* is only, like, the

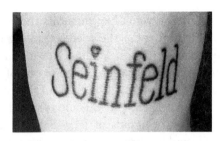

greatest television series ever created. Unlike Jimmy Buffet, their love for the show rubbed off on me. I remember them watching it every Thursday night when it was still on air, sitting on the floor between my father's feet.

It was one of the first "adult" TV shows that I thought was actually funny. I specifically remember laughing out loud at the ending scene of "The Pothole" episode, when Newman is freely driving on the *luxurious* two-lane stretch of highway that Kramer adopted and subsequently spilled paint thinner all over. As Newman belts out the chorus to "Three Times A Lady," his postal truck strikes an old sewing machine that earlier fell from the trunk of Jerry's car, manned by Elaine. The sewing machine gets wedged underneath the axle, grinding against the asphalt and sending out a shower of sparks which ignite into

a fiery inferno when Newman hits the patch of paint thinner on the road, engulfing the mail truck in flames, sending Newman into a screaming panic where he belts out of his large catfish mouth, "OH, THE HUMANITY!" Since then, the ridiculous world derived from the brains of Jerry Seinfeld and Larry David has become a lifelong obsession. This was especially true later when I became a young adult with a more mature sense of humor and an understanding of the comical complexities of everyday life and relationships.

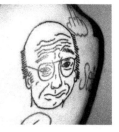

The Larry David tattoo might be my claim to fame. It's probably the one that's received the most "That's stick 'n' poke?!" comments on Instagram. I'd wanted to do this one for a while, but I put it off because I knew it would be a long and meticulous process. Then one day I just went for it as soon as I clocked in. I finished shortly before it was time to punch out. Nearly eight

fuckin' hours of poking! I spent a little more time and effort on this one because I really wanted it to look good and not end up on one of those "sucky tattoo" Instagram accounts. I was proud and relieved at the end of the day. And to think I got paid almost $100 to do it.

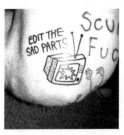

After my parents refinished the basement of our house and moved their bed downstairs, I inherited the master bedroom with a private bathroom. That's a lot of bedroom for a 9-year-old. They let me have a TV in there that they must've acquired in the '70s. It might've even still had a dial to change channels. Every weekday I used to wake up at six in the morning just so I could watch a little TV before I had to go to school. Now, I could play it cool and say that I was only getting up that god-awful early to catch an episode of *The Wayans Bros* before hopping in the shower. But I ain't gonna lie. I was getting up at 6 a.m. five days a week to

watch *Pokémon*. Straight up. I still know all the words to the theme song.

I almost bled to death in in the living room of our home (alone), about a year after I might've gotten a Dragonball Z tattoo. I accidentally lacerated my wrist to the bone on a broken window, severing most of the tendons and arteries. My step-father at the time, Tom Lowry, drove like a fuckin' maniac in my mother's leased Dodge Durango to the emergency room in the nearest town (eight miles away) with his hand glued to the horn as I was fading in and out of consciousness, losing a lot of blood.

I still think about that to this day—Tom risking all of our lives in order to save mine, and somehow pulling it off. I haven't seen or spoke to him in years. My mom decided to inconveniently divorce him just as I started to feel like I loved him as a father. He remarried a few years later to the mother of a girl I went to elementary school with named Kelsey, whose boyfriend at the time of remarriage was also named Tanner. That's the last I'd heard of Tom Lowry. He is one of the rea-

sons why I am still breathing today.

The ER doctors did what they could to stop the bleeding, but I needed surgery A.S.A. Fucking P. to reattach my veins and tendons. So they stuck me in an ambulance and booked it towards the nearest hospital employing surgeons specializing in hand/foot surgery (two and a half hours away). I barely made it, I was told.

The last thing I remember before they put me under, lying on the operating table, was one of the surgeons gasping—*not* at the two-inch wide black hole JESUS DIED FOR MY SHINS in my right wrist—but at a freshly scabbed gash on my right shin that I'd acquired days earlier, skateboarding on a curb in front of an antique store.

We call those injuries "shinners."

I stopped believing in god after I won a writing contest in the third grade. That's a true story. For a short while in college I used to call myself an "apatheist" – a form of agnosticism defined as the belief that the existence of god has no effect on one's life. I

thought it was cool and edgy to tell people, "I don't believe in god and I don't care."

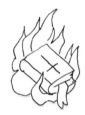

My first real tattoo I got was the Sigil of Baphomet, a *pentagram*, on the day I turned 18 years old. I tried hiding it from my mom, who later denied ever saying she'd sign for me to get a tattoo at such a young age. She eventually saw my freshly scabbed tattoo and accosted me in the kitchen, immediately asking if I worshipped Satan. I scoffed and said no, which was true. It was a stupid trend that went through skateboarding for a bit that I fell right into, like I usually do. But I didn't explain that to her. I just told her it meant nothing. Just like the first stick n' poke I would do with a sewing needle years later (an upside-down cross which was followed by a regular cross, turning it into the VOID band logo). Just like the burning bible I'd poke on my knee four years after that. Just like my beliefs. Just like *Seinfeld*. A whole lotta' nothing.

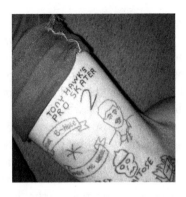

I got a PlayStation for Christmas some-
time in the late '90s. My dad bought me the
game *Tony Hawk's Pro Skater 2* sometime af-
ter its release date in '99, but it practically
went unnoticed because I was too ensconced
in trying to beat *Metal Gear Solid* for the
seventh time or so. Then, in late 2000/early
2001, I picked up a skateboard and never put
it down. Skateboarding subsequently began
to consume my entire life. As my obsession
grew, my collection of Pokémon cards and vi-
olent video games collected dust. I stopped
going to baseball practice and eventually quit
the team. I spent hours skating flatground on
the small patch of smooth concrete behind

our garage. I begged my mom to buy me the newest issue of *Thrasher* and *Big Brother* every time we went to the grocery store. I studied those magazines like they were religious texts. I was happier than I'd ever been in my entire life. Finally.

At some point in my quest to learn everything I possibly could about my newfound love, I remembered that one video game my dad bought me a year or so earlier that I'd only played once or twice—the legendary *THPS2*. I popped the disc in and played that fucker until my hands cramped. Then kept playing some more. If I wasn't outside trying to get my kickflips on lock, then I was inside trying to beat all the levels of *Tony Hawk* so I could unlock the secret skate videos at the end. I was a man obsessed. I still am.

On some meaningless day back in the summer of 2017 I found myself bored at work (no surprise), when I got the idea to look up some songs from the old Tony Hawk games in between calls. I found a playlist on YouTube of the entire *THPS2* soundtrack and I've never clicked a link so fast.

It wasn't surprising that I knew every

damn song on the list, considering the re-
lentless hours I'd spent playing the game
with the songs looping in the background
as a pre-teen. But what was surprising was
that I found myself getting teary-eyed half-
way through "No Cigar" by Millencolin. Shit
you not. The song triggered a flood of mem-
ories that hadn't come to mind in years. I was
time-warped back to 2001—back to when I
first started skating. It was a tsunami com-
prised of all the feelings I had when I first fell
in love with that useless wooden toy. Nothing
compared. Never has an inanimate object af-
fected my life so significantly as a skateboard
has.

(Well, that is, until I got an iPhone.)

Not to be dramatic, but I truly believe
skateboarding changed me. For better or for
worse, I didn't care. Still don't. But it wasn't
just that—that feeling of love. It was pure,
innocent adoration. Skating wasn't popular
back then like it is now. No one did it to look
cool. All we cared about was learning—the
culture, the history, the tricks, the videos—
and more than anything: *having fucking fun!*

It was like I'd stumbled into a secret soci-

ety by accident—a secular club without rules
except the ones we created for ourselves,
without anxiety or guilt or shame or disap-
pointment being forced on you by other peo-
ple who you don't even like. No more Walks
of Shame from home plate to the dugout. No
more pissed-off teammates and dehumaniz-
ing coaches. No more overzealous parents
living vicariously through their children's
lives because they hate their own so much.

I'd finally found something that I was
full-heartedly, deeply passionate about (and
not merely pretending like I did with all the
other sports I was pressured to try out for).
And considering the direction skateboarding
may or may not be heading towards (Olym-
pics, corporate takeover, etc.) along with all
the other bullshit that convolutes it ("*who-
did-what*", silly pants/trends, Instagram, In-
ternet killing the VHS star, etc.), I never,
ever, want to forget what it was like when I
was 12 years old.

Baker2G is a fuckin' cult classic. Like, lit-
erally. Cult shit. The Baker Boys (then known
as the Piss Drunx/Warner Ave. Crew) were

the baddest, punk-est motherfuckers in skateboarding. The only skate crew in history to get covered in *Rolling Stone*, I think. They gave skateboarding a bad name and

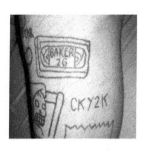

were damn proud of it. Their hi-jinx and de-bauchery spawned an entire army of fans in the early 2000s, labeled as "Baker Clones." And I'm not ashamed to admit I was a re-cruit. The uniform: black Emerica shoes (the all-red Reynolds 1's were like the Holy Grail of all skate shoes back then, besides of course the Osiris D3), ripped up jeans, one of those dorky leather bracelets, and a greasy mop top. That was *the* kit. But there was one thing missing...

Oh man did I want a Piss Drunx tattoo back when I was 14. But nevertheless, I got it when I was 28! Better late than never!(?) If you grew up skateboarding in that era

chances are you probably wanted one too. Or at least you settled for drawing P.D. logos all over your school notebooks and/or griptape. Those who don't know or say otherwise were probably drawing *heartagrams* instead.

I wasn't one of the fortunate skater kids whose parents would buy them new boards when their old ones broke or new kicks when their "school shoes" got torn up a month into 7th grade. If I wanted some new skate gear, I had to wait until Christmas or my birthday to get that shit. If I couldn't wait that long, I'd have to "work" for it.

Between the ages of 11 and 15 my only sources of income were change I'd find under couch cushions and a 20 dollar bill I'd get every two weeks for mowing my dad's lawn—front, back, and later the vacant side lot where a neighboring house should have been that I still had to mow. The pay didn't increase after the purchase of that side lot, yet it was bigger than the back and front combined. It'd take me hours to mow that fucker, shoving a self-propelled push lawnmower with only one hand and holding a Discman

CD player in the other.

I didn't mind it at all though. I actually kind of enjoyed mowing. Mostly because I liked getting money for new skate stuff, but also because the slow, monotonous pushing of the mower paired with the constant cacophony coming from the pull-start motor would create sort of a meditative state for me, drowning out everything in my world, finally giving me a chance to focus and contemplate. (Roughly 10 years later, I'd find that same meditative peace on motorbike in the jungles of Northern Vietnam). I did some of my deepest thinking out there cutting my dad's grass. We had that in common. He said he did all his thinking while mowing the lawn too.

In fact, I was edging around the doghouse near the shed (which was a pain in the ass) listening to "Edit The Sad Parts" by Modest Mouse on my Discman, when I first had the thought, "That would be a cool tattoo."

Tanner Ballengee

I cried the day Dylan Rieder died. That night I sat in my bathroom feeling lonely and depressed and typed, through teary eyes, these words:

"It's so strange to feel heartbroken over someone you've never met. I've been thinking about it all day. It still doesn't make sense. It still doesn't seem real.

We build up people we look up to and admire, our "idols" or "heroes" if you will, to a status above us, unattainable, almost inhuman (god-like, perhaps) to a point where they become invincible. Immortal. That's why it was such a shock to me at first. I forgot that sometimes the heroes in the stories die too. I forgot he was human.

We lost a hero today. But we'll forever have a legend. We all love you, Dylan."

A year has passed and it still doesn't seem real. It's still so fucking sad. I painted my nails black for at least a month after he passed. A lot of people did. Dylan had this tattoo on the side of his palm. I always liked it. Always will.

BACKYARD

On my 26th birthday I went to the bar and got good ol' fashioned drunk. I tried to keep it lowkey but Cheeto kept blowing up my spot. Everywhere we sat someone at the table would buy me a shot. I'd never drank so much tequila in one night. One girl slapped me (with my consent). Another girl went home with me. I woke up in my roommate's bed at 2 p.m., hours late for a "meeting" with my friend Angelo at the Starbucks down the street. When I finally showed up he presented to me his newest business venture—a skateboard company—*Backyard Skateboards*. He then asked if I'd join him for the ride, helping out with what I could. My answer was an obvious yes, and I thanked him for one of the best birthday gifts I've ever received.

Those who've done stick 'n' pokes will know that the best/easiest areas to tattoo yourself are your knees and thighs, especially

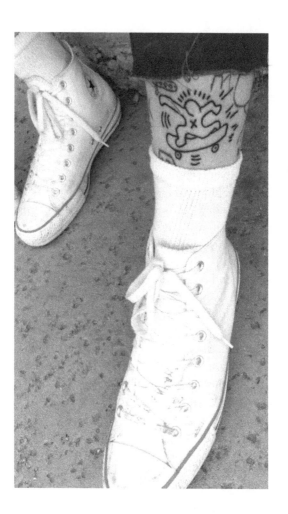

if you are sitting (at a desk in an office chair, wink wink). The Backyard tattoo was a piece of cake—I wore shorts to work and no one suspected a thing. Others, like the Keith Haring piece on my left leg just above my ankle, were a pain in the goddamn ass. Having to reach down, hunched over in a swiveling office chair inside my cubicle, and go over lines at least 9 or 10 times isn't exactly my idea of a good time. But I powerhoused through it.

(Fun Fact: Brian Anderson, who is one of the first if not only openly gay professional skateboarder to come out to the public, has this same tattoo on his forearm.)

Skateboarding has been a huge part of my life, obviously, so it's not that weird to have so many skateboarding related tattoos. This is true about even those without rhyme or reason, such as the *Skate Ghost* (originally drawn by Canadian punk artist Ben "WAY-BAD" Jensen), *Shmoo* (the fat,

smiling blob that came from the beautifully bizarre mind of pro skater and artist Mark Gonzales), and the stupid little skull cruising down my kneecap.

One big reason why I love skating so much is because it's a gateway drug that led me to countless amazing opportunities and rad people that I never would've encountered if I hadn't pulled that dilapidated Walmart board out of my garage almost two decades ago. Subtracting skateboarding from my life would've had the same Butterfly Effect as my parents never seeing *Fast Times*—chances are I wouldn't be the person I am today. So much music I'd never hear, places I'd never travel to, ex-girlfriends I'd never date (which in some cases I'd be okay with). And, possibly most importantly, I'd never have met some of the greatest friends I could ever have, those with whom I'd share the fuckin' greatest of times, biggest of laughs, and most incredibly idiotic of inside jokes.

Before realizing that tattooing myself was a fantastic way to make my nauseating eight-hour work shift go by faster, it

was sometimes close to
impossible to achieve
any kind of entertain-
ment within my cubicle
(I guess that's why they
call it "work" huh? HA!).
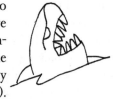
But there was one thing that would spice up
my days when I had nothing else to do aside
from what I was getting paid for:

"I have a pet shark."

Allow me to explain. Occasionally—and
I would only do this under these circum-
stances—when I could *clearly hear* someone
reading *out loud*, word by word, slow as syr-
up, exactly everything I was saying/typing/
captioning on their phone's print-out screen,
sometimes I would slip in a secret, nonsen-
sical, and frankly moronic phrase into their
caption print-out for the sole purpose of
hearing them read out loud the dumbest sen-
tence I could think up: "I have a pet shark."

I know how ridiculous this sounds (and I
love it), but to someone whose been listening
to and repeating thousands of people's con-
versations everyday for three and half years
at $11 an hour, hearing a complete stranger's

voice on the other end of a phone line hundreds or thousands of miles away confusingly read aloud, "I...have...a pet shark?" was the funniest fucking two-seconds in the entire 28,800 seconds of my eight-hour day.

Of course, I would immediately delete the sentence upon hearing it spoken aloud, in an effort to "cover my tracks" and lead them to believe it was simply an error in translation/transcription since nine out of ten people who owned a caption phone thought I was a machine instead of a bored imbecile giving himself tattoos while eavesdropping on their conversation. I compared myself to *Fight Club*'s Tyler Durden splicing PG-rated movie reels with split-second pornographic slides at the theater where he works, only I was a little less perverse. Or maybe I was like the Nintendo developers who secretly hid their names in the first Mario Bros. games. This was my way of secretly and harmlessly disrupting the flow of dull conformity and providing myself with some much needed lulz.

I only told one other coworker, my friend Steven, about my harmless crime, and

I was relieved that he shared the hilarity of the innocent obscenity. He began to join in on the fun that we'd dubbed "pet-sharking." It brought him just as much joy as it did me. Eventually Steven quit, and a year later my career ended as well, forcing my Pet Shark to die there with it. It was a fate I knew would come. No better way to remember it.

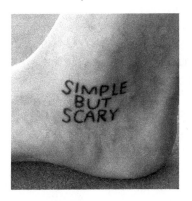

Around 2008, my friend Hunter was talking with his friend Sean, a professional skateboarder in Kansas City, MO, about a certain trick called a *nollie flip nose manual*. Sean commented that this particular trick was, "simple, but scary." Hunter thought the

phrase and his choice of words were insightful yet quite humorous, and relayed what he said to me and some friends in Topeka, KS. We too thought it was funny and began using the phrase ourselves, in regards to just about anything and everything, for years and years.

My body is my journal. My tattoos are my story.

So I guess you could say some of my tattoos are for laughs instead of looks. Which is quite fine by me. Do you really think I got a Shrugging Emoticon Guy tattoo because I thought it looked cool? Ha! Hell nah. I wanted to pair up the worst tattoo ever (a machine-scratched "XNXX" –it's a porn site...) with the second worst tattoo ever, to directly project how I feel about my life choices.

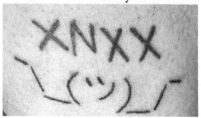

Another prime example of getting tats for laughs is *Your Funeral*. This is one of my

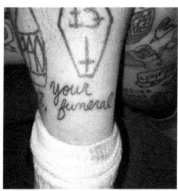

favorite sayings because you can use it as a response to just about anything and it'll almost always be funny.

"Be right back. I'm going to T-Bell."

"Your funeral, bud."

"I'm just gonna have a couple beers and call it a night."

"Whatever man, your funeral."

"I think I got another UTI."

"Your funeral."

See? Told you.

The meaning behind it is about as dumb as it sounds. "Tempeka" is the fusion of the names of the city where I grew up (Topeka) and the city where I currently reside (Tem-

TEMPEKA

pe). Genius, huh? It came to me a couple years ago and I thought it would be a cool name for a skate video. Ended up being a tattoo. It happens. No regrets.

This came after a short resting period during which I didn't do any tattoos. I'd go through phases of different interests and art mediums and general ways to pass the time. Painting, drawing, reading, writing, collaging, etc. I'd usually stick to one or two things at a time before rotating to the next. You've got to change it up every once in a while or things get stale.

I probably got to work that day and said, "Hm...haven't done a tattoo in awhile," dug out the mobile stick n' poke kit I kept in my backpack, traced the tattoo, found a spot, and burned an hour away.

I did the Butthole one for a free t-shirt. I'm not kidding. Well, it wasn't just that. I do like butts. And buttholes. And apparently so does Henry Jones, the artist that drew this.

STISGMAW

He posted it on his Instagram (@henry-jones) during the summer months of 2016 with the caption "free shirt to anyone who gets this tatted"—assumedly joking because who'd be idiotic enough to get such a ridiculous tattoo?

Me! That's who! Plus I had all the supplies to do it myself and plenty of paid time on my hands. I started on it in my cube the very next day and put the finishing touches on it at home that night. I honestly did kind of a shitty job—the letters were small and close together. Mostly because I just didn't care and wanted to send it to Henry before someone beat me to it.

He was stoked. And probably in disbelief. But he kept his word and asked for my address and t-shirt size. He posted the photo of it on his account too. He had over 90,000 followers so it got a viral amount of comments. A chunk of them were just about my Swampy and GG Allin tattoos surrounding

it. A couple weeks later I got the shirt in the mail. I hardly ever wear it.

I'd been wanting a Swampy tattoo for a long time—ever since I met a guy in Minneapolis that had one tattooed on his chest. For those who don't know, "Swampy" is the moniker of a train-hopping crust punk notorious for his amazing travel photography and (especially) his art/graffiti—his most well known piece being the horned skull.

I specifically planned to do this one on a Friday because my supervisor had Fridays off (along with many other coworkers on my "team"), so that meant I could sit in the cubicle opposite hers worry-free since it'd be empty. And because it was next to a wall, the likelihood of someone walking by and seeing me bent over with my face pressed as close

 as I could possibly get to my thigh was slim to none. This was in the beginning of my secret stick and poke career so I was a little timid about it still.

Eventually I got more comfortable and a little fearless, but never caught slippin'.

It took all fuckin' day just like I estimated it would. There are a lot of lines. I used two different needles—maybe my first time doing so on a single tattoo. Later that night a few friends and I held our first "Stoke & Poke" party at my house—an idea I'd come up that functioned like a kind of a stick n' poke workshop get-together for punx and skate nerds; where a bunch of buds could sit around and drink Buds, watch some old classic VHS skate videos, and all tattoo ourselves freely. And all those things went down except for the latter—I ended up doing all the poking. I tattooed three people that first night until like six or seven in the morning: "Made in Oregon" on Corey, a bratwurst on Riley, and a Backyard logo on Tony. I was already pretty drunk when I started and nearly incoherent when I finished. Not some of my best work, to say the least.

At some point I saw a photo of a tag Swampy did that looked like a huge punk-patch stitched to the side of a wall with the words "STAY PUNK" inside. This remind-

ed me of something my ex-girlfriend Sarah told me before my 25th birthday: if you are still "punk" by the time you turn 25-years-old then you get to/have to get a "Stay Punk" tattoo. I never asked if she had one. She was 30. She had small black dots on each of her fingers though, just below the nail bed.

I thought that was a cool idea. I got mine two and half years later.

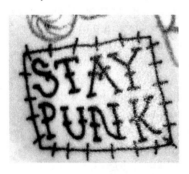

I got a portrait of Bukowski from my friend Aaron Maxwell—a real tattoo artist in a real shop using a real tattoo machine—on a random day-off back before I got into the stick and poke scene and was still dating Sarah. He also did a majority of the tattoos on my forearm. After finishing the portrait I

imagined I would be getting a lot of people/ strangers approaching me and commenting on it. At the time I thought it was pretty obvious that it was Bukowski and that I'd either get a lot of love or a lot of hate. I got neither. Literally no one has yet to say anything about it.

Whatever. *I* was stoked on it. And it was something I'd been wanting for a long time— ever since I got deep into the "Bukowski Hole" in college, as my classmate Leif Anderson once called it. Originally I considered also getting a quote in a banner either above or below his portrait but ultimately decided against it. The quote I had in mind was the first line of his first novel *Post Office*, and also the first words by Bukowski I'd ever read: "It began as a mistake."

Of course, he was referring to his career with the United States Postal Office, which is what the novel encompasses. But personally, I related those first five words to

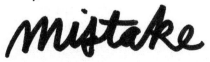

how I began my career in writing—a "mis-
take" I made in college.

Going to college was a mistake. I was
fresh out of High School, working part time
at a pawn shop for $6 an hour, with zero am-
bitions or interests other than skateboarding,
having sex with my girlfriend, buying over-
priced t-shirts on eBay, and not washing my
jeans. Choosing English as my major, with an
emphasis in Creative Writing, was a mistake
(according to my father). Deciding to read
Charles Bukowski was a mistake that led me
to idolize and believe that excessive drinking
and sleeping around with multiple partners
with little to no regard for their feelings and
needs was acceptable behavior, subsequently
planting the overconfident seed that would
sprout and overtake my entire life. "Hell, *I*
could write some shit like this."

The story's all too familiar. I was staring
at the blank spaces on my arms & legs. It was
too late to get the entire quote in the small
space between my forearm tattoos. I settled
for the most meaningful word in the sen-
tence. Instead of fucking with tracing paper
and struggling to get the perfect size, I wrote

it on my skin with a pen a few times until I got it right.

Maybe college wasn't a mistake, but perhaps choosing a university (I'd eventually graduate 5 years later) partially because it was nearby but mainly because it was the one my girlfriend (Tori) would also be attending, wasn't the wisest choice. But of course I wouldn't realize that until later. When it was too late.

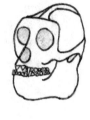

I'm really not even sure if it's actually a Neanderthal skull. Maybe if I'd paid more attention in the Evolution class I took second semester of sophomore year I'd have a better idea. The professor of that course was an older German lady, whom I'd later find was one of the head persons of a renowned Atheist group in Topeka. Makes sense. I took that class with Tori. She dumped me mid-semester. We sat next to each other. Got pretty awkward after that. That's probably why I can't remember what humanoid this skull belonged to.

I've only gotten one speeding ticket in the 12 years that I've been driving. That might be hard to believe to those that don't know me. It also might be hard to believe to those that do know me, considering how good of a driver I am (They call it "driving like a grandpa." I call it being cautious). I've actually been pulled over for going *too slow* before, shit you not. 32 in a 35. The cop called it "obstruction of traffic" and asked why I was going so slow. I responded, "So you wouldn't pull me over."

Nevertheless, I received the one and only speeding violation on my driving record when I was 17-years-old, going 8 m.p.h. over the limit in a rural Kansas small-town speed-trap during the early hours of a Saturday morning, coming down from my first LSD trip.

I told my dad I'd be staying over at a friend's house, which was true. I didn't tell him I was going to one of the "rave parties" that'd been going on at 940—the infamous skate-house in Topeka that would later be-

come my home. I arrived late, walking into the smoked-filled living room with the wrap-around couch where ten or so familiar strangers sat planted like weeds. I had a lot of catching up to do. I found some faded friends sitting at the round table adjacent to the kitchen. Within 15 minutes the giggling, curly-headed one to my left tapped my shoulder and said, "Hey man, you want some acid?" I said yes without a microsecond of forethought.

He handed me a Sweet Tart and told me to put it under my tongue.

"Is it, like...on there already?"

He responded with laughter. I shrugged and popped it in my mouth, feeling very uncomfortable and very sober. After about 20 minutes or so I began to regret my decision. I went to the bathroom and spit the candy out and put it in my coat pocket. No one would know. I didn't know either. I didn't know that it was already too late.

Time started speeding up, and I soon found myself growing roots into the couch with the others, all staring with bloodshot eyes at the real-life TV screen that was the

party. Luckily, I wasn't the only one. About half of the 50 or so partygoers were also on hallucinogens in some form, so I fit right in. Literally. I couldn't get off that fucking couch. I sat there embedded in the cushions watching the controlled chaos of people zip around like I was holding down a fast-forward button. I witnessed an altercation happen a few feet in front of me. I watched it unfold with the same amount of enthusiasm as I would a fight on *Jerry Springer*. After about an hour of seated observation I asked Tori to escort me to the hall bathroom. The thought of being alone felt a little frightening. I didn't realize that her accompaniment would make the situation even scarier, given the information that her ex-boyfriend was hidden in the mass of blank stares, watching us enter the bathroom together. Maybe I should've been more observant. Maybe I should've changed the channel.

The big brute confronted us through the locked door. My blood pressure spiked and an overwhelming feeling of anxiety and defenselessness overtook my body. After giving the door one final bludgeoning with his fist, he

retreated to the front porch. We made a swift escape to the kitchen where a few heads of household, the 940 Veterans, stood smoking Camel Lights and flicking ash into the sink. I didn't have to say much. They could see the fear in my pallid face, and they immediately offered protection and reassurance. God, I love those dudes. They slipped us out the back door, along with a fellow 940 Prospect and his girlfriend, in to the back parking lot where a get-away car was waiting.

At the girl's parent's house, I was able to calm down to the point where I felt comfortable enough to attempt a make-out sesh with Tori, I thought. With my eyes closed, I saw contorting distortions of vibrant colorful waves followed by cartoon characters covered in slimy tentacles drinking out of Bar-N-Grill to-go cups, all set to the tune of "She Bop" by Cyndi Lauper being played in reverse. With my eyes open, I watched in curious horror as Tori's mouth and face mutated into what resembled the mandibles of a crawfish or a lobster. That was enough. I pulled away, apologizing.

I sat hugging my knees on the floor

against the edge of the bed until the other three fell asleep in it. Minutes went by until two house pets—a black cat and a golden retriever—entered the room and took seats directly in front of me on the carpet. They both stared at me silently and unwaveringly. I glared right back. The staring match continued for hours without movement or sound, until the sunrise came through the attic windows and provoked their exit. I followed suit and left unnoticed through the front door, finding myself in complete bewilderment that my car was somehow in the driveway.

I still didn't feel like myself, although the visuals and hallucinations had subsided. After about 30 minutes of driving I thought I felt a resurgence of the drug in the form of revolving, flashing colors, dancing to and fro in my field of vision. I blinked and rubbed my eyes hard, but the colorful lights were still there. Red and blue. In my rear view mirror.

I was blasting the album *Somery* by the Descendents on repeat around the time I starting seeing Cristina exclusively. I fell a little more in love when I played "Hope" and she began singing along word for

word. Much like our relationship, tattooing yourself on your lower shins is a pain in the ass. I'm not very flexible as it is, let alone the fact that I was sitting in a chair with my leg hiked up on my desk, trying not to look conspicuous. But before Cristina there was Catarina.

"Fortunate Son" is a song by Credence Clearwater Rival. Jamie Thomas skated to it in Zero's *New Blood* video. I love that song and CCR in general, and so does my dad. But I relate to the title "Fortunate Son" itself more than the actual lyrics of the song.

My parents only had two children—Taylor and I. Taylor was born with Autism. It's hard growing up with an autistic child/sib-

ling, but my parents and I loved the shit out of him regardless. And we persevered. As we grew older and learned more about each other, some nights I'd lie in bed thinking about my brother, born into a tough life through no fault of anyone. He didn't get Autism from anything my mother did during pregnancy. She didn't smoke. Didn't drink. Never even consumed any damn caffeine. And he definitely didn't get it from any fuckin' vaccinations. He just got the short end of the stick. That's it. It happens all the time.

I'd lie there and think about how the world is shitty enough and hard to get through as it is. Why the fuck does his life need to be even more difficult? Thinking these things eventually gave way to overwhelming feelings of guilt. I felt guilty that I was the "lucky one," born virtually with no health problems or defects. The fortunate son so to speak. I felt like I didn't deserve it, and neither did Taylor. *It's not fucking fair*, I'd say. *It ain't me. I ain't no fortunate son.* Or at least, I shouldn't be.

Catarina moved away but would still come visit every couple months, and we'd

always spend time together. Then one miserable Monday I woke up hungover as fuck to a text message from Cat saying that she was pregnant and the baby was mine. What a way to start the workweek.

I was shocked and honestly dumbfounded. I'd never slipped one past the goalie before in my life, or even had a scare frankly. I take medication that lists sterility as a side effect and I always execute *coitus interruptus* (Latin for "when in doubt, pull out"). But I gave her the benefit of the doubt and didn't question or deny her claim. Accidents do happen. And I didn't think she'd ever lie or exaggerate about something that serious. We agreed to meet when she'd be in town a week later to discuss what to do. I told her she had my full support in whatever she decided, even though I personally did not, in any circumstance, want an unplanned baby. She was an ex-girlfriend for a reason.

We met in a park by the lake to discuss our options. She probably knew what I wanted to do, but I wasn't going to say it aloud until she did. She slowly told me she was currently in no position in life to have a child,

and I wasn't either. I wholeheartedly agreed, and told her I would split the bill with her 50/50. It was settled. We made plans of when and where, and decided to keep quiet about it to others while also keeping in touch with each other. We hugged and parted ways.

She wouldn't fly back home for another week, but it was only days later that she texted me at work saying that she had been having agonizing abdominal pain for hours and that bloody, clotted things were coming out of her. It took me about 15 minutes before realizing what actually might be happening, frantically googling her symptoms between calls.

I skipped dinner and picked her up straight from work and took her to the ER. I waited fuckin' forever to hear to official results, sitting by her side as she bled through her gown and underwear onto the hospital bed. Tests, scans, the whole nine. It fuckin' sucked. I hadn't thought about it much, but if I did, I pictured myself seeing my first sonogram of my child while holding hands with a woman I loved, in a warm and sunny room, watching the black screen with

loving, tear-swelled eyes, patiently await-
ing the announcement of the sex. Not cold
and stressed-out in some dark corner of the
ER, biting my fingernails till they bleed with
someone I *kind of* dated once but still fucked
now and then, impatiently awaiting to hear
if the clump of cells in her uterus was alive
or not.

 We both had a feeling what was hap-
pening inside her body and were more than
okay with it. A "blessing in disguise" so to
speak. Thinking that caused even more guilt
to grow inside me. This would be absolutely
devastating to an expecting couple. And here
we were thanking our lucky stars. And to
make things worse, it seemed like the tech-
nicians and nurses were tiptoeing around giv-
ing us the final verdict—as if they were afraid
the news was going to destroy us. Maybe we
should've mentioned that not only we were
not planning on keeping it, but we weren't
even together. And... we were actually in a
hurry to get to the bar before last call.

 Meanwhile my stomach was screaming at
me because the two veggie hotdogs I had for
lunch were not very satiating. I asked Cat if

she had any one-dollar bills in her purse for the vending machine. She dug around for some cash but no dice. She did however find something edible: a single fortune cookie still packaged in clear plastic. I thanked her, opened it, and broke it in half, eager to force some contrived meaning out of the two line "fortune" on the slip inside that I could apply to our situation. I uncurled the paper to what I thought could possibly be some holistic closure to the fucked up situation or something I could tattoo on myself months later, only to reveal...nothing.

The little slip of paper was blank on both sides. I'd never heard anyone getting a blank fortune cookie slip before. How funny, I thought, that I wanted to force meaning out of something so badly but wasn't even given the option. And even funnier, I thought, that I derived meaning anyway. Creating something from nothing. The fact that I had no fortune was a fortune in itself. *No fortune*, I thought.. *No fortune... No son...* No, fortunate son. Again. And the guilt that comes with it. Again.

STISGMAW

I have spectacular gay-dar. I don't know why. Maybe it's because I'm kinda gay. Regardless, I have this ability(?) and it's been foolproof so far. Granted, I realize now that sexuality is a spectrum, so when I think someone might be gay, either secretly or unknowingly, I'm really speculating that they are simply more gay than straight. In retrospect I don't think it's really that simple. Plus I've only used my gay-dar three times, and all three guys I thought might be in-the-closet all came out years later. This is the third one:

When I first met Tori in 2007 during my senior year of High School, I had an undeniable feeling right away that her boyfriend was probably predominately homosexual. I'm not sure why I get those senses when I do, but maybe it had something to do with his voice, his mannerisms, the fact that they never had sex, etc. I think Tori had those thoughts too, because when she heard from her friend who heard from her boyfriend that I thought she was a babe, she dumped the dude and started joining her friend who used to come around the skate-house I lived in solely in hopes of hanging out with me. I didn't care at the time

but I might've felt a little guilty later on (apparently he was telling people that I "stole" his girlfriend, which I essentially did). But last I heard my gay-dar was accurate once again and he came out years later. So I'd like to imagine he's much happier now.

We fell in love swiftly and dated for a little over 2 years. We both started college together (Washburn University) and I did poorly my first few semesters because all I cared about was her. And sex. And skateboarding. Eventually I got my shit together. But as my GPA slowly improved, our relationship gradually began to suffer. There was no correlation between the two—I was just an immature little shit-head who was still uneducated about how to treat a woman/partner and have a successful, loving relationship. So my (our) ignorance paired with stubbornness ultimately led to our demise on March 22, 2009. Just a couple weeks away from my 20th birthday.

Some people (typically my partners) think it's weird that I remember the exact date. Like it's scar tissue in my heart or something. Nah. I mean, it *was* a shitty break-up

for me, and I was sad for a long time afterward, but the only reason I remember the exact date is because I wrote it down. See, before I officially declared my major in English I was already getting back into writing after not giving a shit for years. And the sole reason I picked it back up was to use it as a coping mechanism to deal with how depressed I felt about my failing relationship. I picked up a red spiral notebook and turned it into a pathetic sad-boy diary. I had only scribbled out a few whiny entries before she finally pulled the trigger. I was pretty fuckin' bummed. The only thing I could do was write down the date and start a new entry.

Several years and lovers (Sarah, Catarina, etc.) came and went, and in 2016 I once again found myself in a failing relationship and a mild depression. I'd gotten used to being an asshole, but I guess I didn't like the taste of my own medicine. Serves me right—I got a full dose this time. It's worse to watch something die slowly before your eyes than to execute it immediately. I think Neil Young said something similar. So I suffered until the inevitable finally happened. I cried on my

morning walk to Starbucks. Luckily I had my sunglasses on. I think the barista could hear the sadness in my voice because she gave me my coffee on the house. Her kindness made me tear up even more. When I got home I sat and smoked on my front porch for what might've been hours. Feeling nothing and everything. I pulled my phone out when I felt it vibrate, desperately hoping it was Cristina. Nah. It was a reminder to put the recycling out by the curb, which made me look at the day's date. March 22, 2016. I fumbled. I thought about why the date rang a bell; why I thought it meant something. Seconds later I whispered, "There's no fuckin' way," and extinguished my cigarette to search for that red spiral notebook—the first journal I'd decided to keep after completion instead of destroying it like I usually would have.

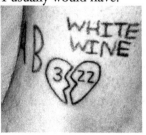

STISGMAW

Sure as shit, there was a fuckin' way. Exactly seven years apart. I couldn't believe it. Maybe that's one of those old wives' tales or whatever—Your heart breaks every seven years. Hmm, how about that? I almost wasn't sad anymore due to the amount of shock that came with the absurdity of the coincidence. I felt like telling someone. I needed someone to share the moment with me, make me feel like I wasn't crazy, and stretch the feeling out before it faded and the sadness seeped back in. I thought for a moment about who until an interesting idea came to me. I called Tori.

She wasn't as enthusiastic about the 3/22 coincidence as I was, putting more energy into telling me how stupid she was back then and how it was a mistake and she wishes she would've blah blah blah... I was flattered, but it wasn't what I wanted to hear.

This time around, I must've thought that dating a journal entry wouldn't have been enough so I poked it right into my fucking skin the next day. Looking back at it now, I'd say it *is* kind of *interesting* that I got severely dumped on the same day, seven years apart, but it doesn't mean anything. I tried to make

meaning of it, like I normally do, but in reality it was nothing. It was merely an overwhelming feeling that, instead of burning out, slowly faded away.

I have other meaningless tattoos that are less embarrassing. Like the Smoking Girl for example, that I did as a challenge more than anything—seeing if I could do something aside from skateboards and skulls; the Broken Arrow that got a little infected; or the Jean Michael *Basquiat* crown on the inside of my right knee. I've tried watching that Basquiat movie at least four separate times but I always end up falling sleep halfway through. I love his drawings but I was way too novice at handpoking at the time to attempt anything like that. So I got the crown tattoo that I'm guessing thousands of 19-year-old art history major hipsters also have.

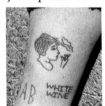 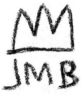

STISGMAW

On the topic of cliché tattoos—you'd probably assume that I did the Prince symbol after he died. And you'd be right! When I got off of work on the day he passed (April 21, 2016) I bought a 40 oz. of Budweiser and drove a few blocks to this alley by my house where the a big capitalized "PRINCE" is spray-painted on the wall, to pour one out for our deceased royalty.

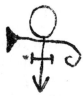 I went to the bar later that night and ran into Cristina, roughly four weeks since she gave me the boot. We ended up talking for a while. She was giving me vibes left and right (the good kind) and after a couple hours we ended up leaving together on foot. She claimed to be a big Prince fan (even though I'd never heard her ever mention him in all the years I'd known her), so I decided to take her to the graffiti'd wall where I'd poured beer out at earlier on the way back to my house. We stole flowers from various bushes and buildings along the way, making a big, beautiful conglomerate bouquet, and left it under the spray-painted makeshift memo-

rial. We slept together that night. And decided to give it another try the next day.

I gave Cristina a few tattoos throughout our relationship. I never gave her a Prince one though, and she was a little ticked off that I did it on myself 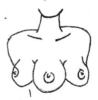 before her, claiming I wasn't a real fan. There were a couple others I never poked on her as well, like the three-breasted woman from *Total Recall* (which I've never actually seen but I've heard plenty about the "chick with three titties" to know what she was talking about), or the Light Bulb that she wanted for some reason. I can't quite say why I never did these tattoos for her, but it was probably either because she didn't like what I drew or because we'd broken up. Again. And again. Needless to say she wasn't exactly thrilled when she found out I did *her* tattoos on myself, on the same day, just to waste time at work.

Now that I'm thinking about it, I think

I might add, "discretely tattooing myself" to my resume under my daily duties/responsibilities for this job. Why not? I was pretty damn good at it.

One of my more recent ex-girlfriends has several stick n' pokes from me. Maybe ten or more. The Vase Face was one that (unlike my other ex) I tattooed on her first and on myself later. But much like the others it was a total time-consumer. I mean, not to say that it was a waste of time—I was getting paid by the hour—but as to say that I didn't want it that bad. It's cool art but I could've lived without it. Hence why it's not very dark. The calf is a hard place to tattoo (especially on yourself) because it's so soft and fleshy. Normally I would've gone over it a few more times, but fuck it.

I was chastised for my pentagram in my last year of High School because I'd gotten the official symbol of the Church of Satan as my first tattoo for little to no reason. Calla,

one of my only friends at that school, was a Valedictorian punk chick who was born with a disease that made her bones extremely brittle. She tried to ease my insecurities about my first tattoo by advising me to tell anyone who asked that it wasn't an appropriated symbol for LaVeyan Satanism but actually an appropriated logo for Leftöver Crack.

I had no clue what the fuck she was talking about.

Skateboarding introduced me to punk music at a young age but I ignored it until I was delivering pizzas in my early 20s, hearing the band Leftöver Crack for the second time of my life and finally understanding what the fuck Calla was talking about. My interest in the genre would then build and snowball like so many other things in life. Eventually I reached a point of no return when I witnessed a friend blasting the shittiest sounding song I'd ever overheard, sitting alone in his car in a skatepark parking lot. When he'd finally stumbled into the park I asked what he'd been listening to. With a proud, crooked and yellow grin he answered, "Johnny Hobo and The Freight Trains!"

I was fucked. I was a confused, depressed, budding alcoholic just starting to get into punk music, like, eight years too late. The last thing I needed was to start listening to Johnny Hobo. It was like Bukowski set to music, except for 13-year-old posers that hate their parents and want to run away from home but are too scared to hop a train. I fuckin' loved it. I became obsessed. Not with just the subgenre (*folk punk*), but with the whole idea of punk traveling—riding freight trains, squatting abandoned buildings, hitchhiking, being "dirty, broke, beautiful, and free." Essentially, running away from problems. I sounded so much better than dealing with them.

I wanted to be an oogle so bad. By oogle I mean one of those crusty trainhopper punks. So that's what I set out to do. I never rode any trains but I did travel and slept outside a lot—under bridges, in abandoned houses, Buddhist temples, bus stops, houseboats, corn fields, etc. Never any real squats, though. So I guess that makes me a poser.

But regardless of status, punk introduced me to one monumental thing in my life—stick and pokes! And I can be forever grateful for that. I was still learning the ropes at the time I did the Squatter's Rights symbol, using whatever spare needles we had at our house, sometimes reusing the same ones more than once. Yikes. I didn't realize that tattoo needles on Amazon are dirt-cheap and come pre-sterilized. Which meant I wouldn't have to "sterilize" reused needles by heating up the tip with a lighter, like I used to do with the sewing needles. Like the two-cross Void symbol on my ankle mentioned earlier. (And the anchor on my kneecap that I'll get to in the next chapter.)

Despite the lack of cleanliness and sterility, none of my stick n' poke tattoos ever got infected. In fact, the only tattoo of mine to ever get infected was the Black Flag bars logo in the "ditch" of my left arm that was done by my tattoo guy at a legit tattoo shop. I'd heard plenty horror stories about how much getting the ditch tattooed sucks, and I wholeheartedly agree with that notion. I tried to keep it as clean as I could but it was

no use. It scabbed horribly and the constant movement of my arm would rip the scabs open over and over again, giving zero chance for proper healing—hence the scarring. Thus the "DAMAGED" poke I did (in freehand cursive!) above the bars gets a double meaning: a reference to the quality of the tattoo as well as the Black Flag album bearing the same name.

A whole slew of shitty punk music found its way onto my iPod when I was 23—about a decade too late for that angsty bullshit. But I loved it, in a new way than I did when I was 13. It probably had a lot to do with the depression and anxiety I was going through at the time. I had a mental and emotional breakdown a year prior. The only things surpassing my urges to drink until blacking out were my urges to die. I didn't handle stress very well. I couldn't cope with anxiety—just drowned it with booze instead. I slept around as much as I could with whomever I could because promiscuity made me feel better about myself. I thought.

When I hit my breaking point I finally

asked for help, around 3 or 4 a.m., from none other than my parents. I met with my dad about a week later in a Target parking lot and watched him cry for the third or fourth time in my life, blaming himself for my spiraling misery. God, that fuckin' sucked.

I got into a treatment program for my moderate alcoholism and mild depression. Basically just therapy sessions with a woman named Shelly. I had the option to choose between a male or a female therapist. I guess I thought I'd be more comfortable with a woman. I sat in her office rolling my eyes and sighing heavily for 50 minutes once a week for about three weeks before she finally "broke" me, and I ended up sobbing for the second half of our session. Until that moment I'd been so annoyed because I just wanted Shelly to "fix" me. Turns out that you have to fix yourself in therapy. You actually have to *work* towards getting better, not just have some licensed professional do it for you. It's no fuckin' cakewalk.

It was starting to work for awhile, and I was doing good, but I eventually gave up on it because there were some things I was

unwilling to do (i.e. stop drinking, confront my parents about pent up resentment, etc.), not to mention my dad was getting frustrated since he was having to foot the bill for my therapy because his insurance wouldn't cover it. Instead of explaining that he was part of the reason I was in Shelly's office in the first place, I took the easy route and stopped going. Leaving therapy unfinished put me in a toxic mental state. Ironically, I found myself with a newfound feeling of hate for the very people I asked for help in the first place.

Giving up left me with an overwhelming desire to not only drink like a fish but to run away. Punk music only fueled those urges. I remember listening to that Leftöver Crack song "Ya Can't Go Home" while delivering pizzas and wanting to be living the crusty traveling life the lyrics formed in my head. Eating pizzas out of dumpsters instead of putting them in.

(SIDE STORY: I have no clue why I do it. There must be something buried deep in my subconscious. Some repressed memory from my childhood perhaps. Or maybe something to do with my mom. I don't know for sure—I

can't figure it out. But every time I listen to "Fast Car" by Tracey Chapman I fuckin' *cry like a baby*. Seriously. Whether it's a couple tears rolling down the cheek or a full on sob. Every. Single. Time. I bring this up because I specifically recall a time, delivering pizzas, where seasonal allergies were making my eyes and contacts so irritatingly dry that I could barely see the road through my windshield.

So to remedy that I got the idea to listen to "Fast Car" between deliveries in order to rewet my eyes and see clearly for a few minutes. It worked like a fuckin' charm.)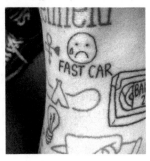

So I flew to Bangkok after I graduated college, with no plans whatsoever aside from meeting an old friend, Conner, at a grimy hostel in the city and going from there. We ended up buying motorbikes and barging all through SE Asia—Vietnam, Cambodia, Thai-

land, India, and Nepal. Our goal was to travel as punk and inexpensively as possible, mainly by never staying in hotels. It was a fuckin' hell-ride of an adventure, lasting over three unforgettable months, leaving me broke as a joke with more gnarly stories than I could tell, and a check mark on my bucket list.

One unchecked article on said list was brought up somewhere along the way. I mentioned to Conner that one thing I always wanted to do as long as I'd been listening to music was be in a band—but not just that—I wanted to be in a band *performing onstage*, to a real live audience. Conner, who actually had been in bands that'd performed on stage, tossed around the idea of creating a band someday when we'd both find ourselves in the same country with a lot of free time on our hands. A temporary band that we'd dedicate our entire lives to for a set period of time. We'd put our full effort into it up until its expiration date and then abandon it forever. It was an interesting and fun idea, and I dug it immediately. The idea had been conceived. Nine months later, Yak Bastard was born.

One of my favorite contemporary art-

ists is the late Dash Snow, even though some might say he was just a hipster junky that ejaculated on things and called it art. But he had something that a lot of people don't. I'll call it guts. And style. One of my favorite quotes of his comes from a three question video interview where he's asked, "What keeps you alive?"

His answer (aside from 'two jugs of water' and 'two packs of Marlboro Reds') was, "Music. I have to listen to music all day long. I'd say that keeps me going. I'm a pretty dark person. I've thought about ending it a million times, and I have to say music keeps me here. By far, the main thing. That's what I wish I did do was music but I just haven't got there yet. Maybe one day."

My sentiments exactly. I love music so much and have perpetually daydreamed about being on stage in front of a crowd of people some day, but for one or more reasons it had never happened to me. Or rather, I never tried to make it happen. Unfortunately, that one day never came for Dash. I was worried I wouldn't see my day either. So when the ideas of Yak Bastard began to brew,

I knew this was my chance to do what I'd always secretly wanted.

One of my favorite things about the Yak Bastard project was seeing how many of my friends were secretly musically talented (and consequently, which ones weren't). Seriously, who would've known our friend Mark had such entertaining vocals? Instead of just doing it ourselves (which we totally could've) we wanted to give all our friends the opportunity to join in on something cool with us. We invited the whole community to come do something most have never done before: *be in a punk band*, one immortalized forever in a city where every potentially rad idea is continually stomped out to die. And not only there. We reached out beyond Topeka and collaborated with like-minds from different states like Missouri and Minnesota, as well as foreign countries like Sweden and Thailand. People screamed and wailed instruments into phones and computers and we used whatever they sent us no matter how bad the quality or unfit the tempo. On the surface, Yak Bastard was just two people (oh yeah, and Troy), but we wouldn't be shit without the 50+ people

that helped make us the shit show that we became. Yak Bastard was a fiery blaze that grew out of control and consumed hundreds of people, almost destroyed an entire house, and nearly killed our front man. But it had to happen, and thank yak that it did.

"Blowjob repellant" was a phrase I came up with to describe my first Yak Bastard tattoo—a "scratcher" below my pantline next to my pubes that a friend gave me after I returned to the states from SE Asia. I labeled this tattoo as "blowjob repellent" because for the following five months, not a single sexual encounter I'd somehow find myself in involved any slob on my knob—a fellatio-dry-spell I'd never experienced before since I lost my v-card at age 16. I didn't understand it. The only explanation for it I could think of was the shitty-ass tattoo on display parallel to my penis. It scared them away.

(It might sound like I'm being dramatic, but if you saw it in person you'd probably think twice about sucking my dick too.)

It's a horrible sketch my friend drew of

a man with X'd out eyes and a mohawk, a bottle in one hand and a case of beer under the other, "Yak Bastard" scrawled out below him. The shitty Mohawk guy is supposed to be Troy, our loud-mouthed, cantankerous, belligerent "front-man." I put that job title in quotations because he didn't really do anything in the band. He couldn't play any instruments or remember any lyrics. He just got blackout drunk and yelled. For our first show we just stuck a homemade yak mask on his head and put him front and center on stage. He sort became the whole image of Yak Bastard after that—the whole embodiment of our gimmick.

And Troy embraced it. Being in that band inadvertently ruined his life for a while (and everyone else's too), 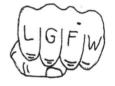 but he can't deny that he fucking loved it. One reason why he can't deny it is because not only does he have a horribly stupid Yak Bastard tattoo like I do, he has three! One similar to mine on his calf (done in my living room with a sketchy homemade machine

with a guitar string), and the titles to two of our songs on his knuckles—the acronyms "G.Y.D.I." and "L.G.F.W.," which stand for "Get Your Drinks In" and "Let's Get Fucking Wasted." Groundbreaking stuff, I know.

As an homage to Troy, whom I have not seen or spoken to in years and has blocked me on Instragram and Facebook, I tattooed a rendition of one of his fists on me. Just one. You know, because having two Yak Bastard tattoos is bad enough.

I wrote an anti-racism song after witnessing a couple of drunken rednecks heckling an Indian girl at a sports bar. Keep in mind I'd just gotten back to the US after spending over a month in India, where I'd met so many kind, beautiful people. So seeing those two assholes harass that girl infuriated me even more than it normally would have. I remember *seeing red* sitting at a table with my friends, completely oblivious to their conversation. I actually wanted to *kill* those white trash bigots. Instead, I pulled out my phone and began typing out a new note:

STISGMAW

Bigot ignorance
Of racist pigs
Reminding me of the state
In which I live

The "state" was Kansas, not my current state of murderous rage. I continued typing, recalling texts I'd read in my "Society & Law" course I took during my last semester of college:

Obama's half black
But millions rot in prison
Labeled by their color
And the chance they weren't given

Then a chorus, followed by one of my favorite verses I ever wrote for Yak Bastard:

Throw away the crosses
FLY A BLACK FLAG
Crucify the racists
TAKE THE COUNTRY BACK

Burning down the churches
Will not end in our peril

But all the extra wood
Will light a thousand barrels

I overheard a guy sitting at the table with the redneck racists saying something about their disgusting behavior being permissible because one of them had done a tour in Middle East with the Army or some shit. This pissed me off even more because it reminded me of my own racist step-father, who'd also served in Iraq and Afghanistan and had nothing but horrible things to say about the native people of those countries. I resumed typing:

Don't care where you're from
or if you've seen Iraq
'cause ignorant intolerance
Will get your ass attacked

Throw away the crosses
FLY A BLACK FLAG
Crucify the racists
TAKE THE COUNTRY BACK

I titled the song "Crucify The Racists," which is an homage to yet another song by Leftöver Crack, titled "Gay Rude Boys Unite!" which contains my favorite lines ever written by the band:

And in a better time on this shitty little globe/We'd crucify the racists and be bashing all the homophobes!

(SIDE NOTE: If you're into good stick n' pokes and the hand poking scene in general you should check out a person who used to go by the handle @homepoke before later

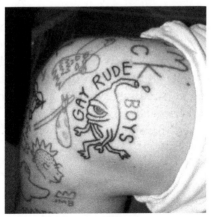

going by by "Sally Rose." I thought I'd read somewhere that they changed it again, but it seems their Instagram has been deleted or changed so I can't confirm or deny that. Regardless, I saw in a photo of Sally that they also have a "Gay Rude Boys Unite!" tattoo. I was stoked on that. I paired mine with the iconic Toy Machine Transistor Sect because why the hell not? My favorite Toy graphic has always been the "Let's Dock" one with the two Transistor Sects docking their head-tube-things. Google it.)

My Shaking Hands poke was supposed to be an anti-racism tattoo of sorts. I was planning on shading/darkening one of the hands after it healed, but I never got around to it. I also thought about adding some words around it ("Fuck Racism" maybe?), but there wasn't enough room. I also thought about getting an X-ed out swastika at one point, but that would mean I'd have to tattoo a swastika on myself first (before crossing it out).

That didn't sit well with me. I also didn't want the possibility that someone might see it and think that I'd gotten a swazi tat a long time ago and then later regretted it. I decided to not fuck with it at all. I'll add shading to one of the hands someday.

Choking Victim came on Christmas day. When I worked for the relay service company, I would always volunteer to work on Christmas day. I have no family in Arizona, so there's really nothing for me to do on Christmas except maybe drink a few beers. Even when I had six or more roommates they were all away with family, leaving me home alone and bored. Honestly I don't mind it. It's actually fuckin' great to be alone for that long when you have that many roommates. And it doesn't even snow here so it doesn't even feel like Christmas.

It just made sense econom-

ically for me to work on December 25. It helped give the day off to coworkers with family, gave me something to do instead of sitting around at home getting drunk and watching *Home Alone II* (although that does sound awesome), and I also got paid time and a half on top of eight hours overtime. I'd be a dummy not to take that, especially if it was on a weekday that I'd normally be working.

Aside from the holiday pay and the free food that management would provide in the break room, another "incentive" we got for working X-mas was that they would allow us to wear sweatpants or pajamas to work that day. Yippee. I'd already been showing up in my Thrasher sweatpants here and there for weeks and no one had said anything. I'd also been tattooing myself everyday for months and not a word about that either!

The sweatpants made it easy for me to do this one far up on my thigh, where I still had tons of room—I wore a pair of b-ball shorts under my sweats so that when I wanted to do the tattoo I could just pull them down to my ankles and get to work. Nothing sketchy

about that, right? No one noticed. Or if they did, they didn't care. Hell, neither did I.

I floated down the entire Mississippi River during the autumn months of 2013, starting at the Headwaters in Lake Itasca, Minnesota with four other people in two 17-foot aluminum canoes and finishing 100 days later with one friend in a 22-foot sailboat near the Gulf of Mexico. It was the most unbelievable, thrilling, terrifying, amazing, miserable trip I've done yet. And Yak Bastard was to blame. The initial idea was that this would be a "tour" or sorts (which is quite possibly the most creative yet dumbest concept we could've ever thought up), in which we'd stop at all 90 or so cities along the river from Minnesota to Louisiana and "busk" or play Yak Bastard songs on the streets.

The first few weeks were a complete shit-show, if you can imagine that. We only busked once in Bemidji, which is the first city on the river. We pretty much scrapped that idea after that and didn't touch our wet, waterlogged instruments until a couple months later.

(SIDE NOTE: If all this seems a little hard to believe, fear not! because we documented the hell out of it—it's all online on our travel blog: theharshbarge.blogspot.com.)

The Headwaters of the Mississippi, which is the beginning part of the river between Lake Itasca and Minneapolis, sees a lot of recreational activity such as fishing, canoeing, and camping. So much so that the Department of Natural Resources in Minnesota built designated camp sites along that first stretch of the river for canoers and fisherman to stop and camp at along the way. Each campsite is marked with a sign bearing a tent and canoe, just like the tattoo.

We tried to camp at one of these spots whenever we could because they were cleared out and well maintained, each with a picnic table and fire pit and occasionally a small shelter. But sometimes (realistically...most of the time) our pace was too slow and we couldn't get to one

by nightfall and we'd have to sleep on riverbanks or patches of tall grass or fields on farmland. Those nights sucked. So it was always a pleasant surprise and huge sigh of relief to see one of those wooden signs pop up around a river bend at dusk after eight hours of paddling.

I never thought I'd take a good place to sleep at night for granted. It was humbling. I never wanted to forget that feeling.

Before doing stick 'n' pokes a couple friends of mine bought one of those cheap tattoo rigs online and started doing scratchers on themselves at home. It's weird how exciting free tattoos can be to a few 23-year-old skaters after a couple 6-packs of PBR.

Before getting the blowjob-repelling Yak Bastard tattoo, I'd always wanted to get my initials on my kneecaps—"T" on my right & "B" on the left. I cringe thinking about it now but back then I thought it'd be totally badass. I had my friend Brady do it for me. Freehand. Goddamnit. They turned out shitty, obviously, but it was me who was to blame. That's what I wanted and that's what I got. It

Tanner Ballengee

hurt like fuckin' hell too.

A year later I'm balls-deep in the Mississippi River (literally!) on this ridiculous voyage. After 50 or so days in a canoe we ended up at the small river town of Prescott, WI, where Conner (the only friend who hadn't quit and gone home) and I randomly met a guy who ran a tattoo shop.

He was a super solid dude—bought us veggie foot-longs at Subway, bought us beers, and even let us crash at his place. He even said he was gonna give us both a free tattoo! He said he wanted to give us anchor tats in respects of an old sailor's creed—something about the anchor representing stability, and also something else about it being good luck against drowning, which was my greatest fear at the time. I was down as fuck for that.

Unfortunately the free tattoo sesh never went down. Bummer. The guy's wife, who ran the tattoo parlor with him, voted against the idea, saying that we wouldn't be able to properly care for our new tattoos. She was right, but her concern was humorous considering the lack of caution, sanitation, and forethought I've put into the majority of my

tattoos. I ended up giving myself an anchor tattoo regardless a couple weeks later by adding on to that capital "T" on my right kneecap (which was the only tattoo on my right leg at the time). It's not the greatest work but it's not bad considering I poked it using an old bent sewing needle with India ink, bobbing up and down in the cabin of our 22-foot sailboat somewhere in Louisiana with four beautiful Canadian canoers that'd hitched a ride with us a few clicks upriver. Weird, wild times those were.

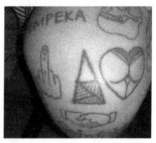

So, that left the stupid little "B" by itself on my left kneecap. It stayed a stupid B for three years until I figured out my little jobhack. I tattooed in the spaces around it for months, trying of think of something I could turn it into. No dice. Sorry for the anticlimax. I literally just started poking around it one day until it ended up being a stupid triangle. And that it shall remain.

The food we ate while traveling down the river was pretty shitty. Conner is still a die-hard vegan and I was a vegetarian back then. Since we were either cooking over a campfire in the woods or on a tiny cook stove in the boat, nine times out of ten our meals consisted merely of chopped up potatoes and onions. Pretty boring and bland no matter how much garlic salt you rain on them. We were constantly looking for anything to make our meals taste better, or taste like anything at all. One of those things was barbecue sauce.

Literally the only reason why we picked Sweet Baby Ray's is because we thought the name was funny. We used to say it all fast and overly dramatic like "Suuhhweet Baybee Raaaaay's!" and laugh like a couple of very bored morons. It was pretty good but I didn't think it was anything great—it just made our meals taste like barbecue sauce—it was the name we were hyped on. So much so that we eventually decided to

buy an entire gallon jug of it, just to say we'd done it. We even wrote and recorded a song about it with our Canadian canoer friends one night in Baton Rouge where we all squatted an abandoned houseboat or floating restaurant or whatever the fuck that was.

(If you want to hear it go to soundcloud. com/yakbastard and it's the second song down. Much like my collection of leg tattoos, the song is pretty terrible but was a lot of fun to make.)

I can't remember the last tattoo I secretly did while at work (like I said, these are not in chronological order) but the Skateboarding Skull had to be one of the last ones, along with the Pet Shark, Thick Chick, and Acid Tongue—all of which I did in one day, within the same eight-hour shift. I poked them one by one in a line on my right kneecap, filling up the last bits of empty skin on the front of my right leg, front mid thigh to ankle.

I had no end goal to this rebellious stunt of nine-to-five fuckery. As I've stated many times already, I was mostly just trying to waste time. My time? Company time? I'm

not sure. I wasn't planning on covering the front of my shins to the point of looking like the cover an old ninth grade Algebra book, but that's what I ended up with. I wasn't planning on making a book about it either, but that's what I ended up doing. Was this just another attempt to waste time? Do you feel like your time has been wasted, reading all this? Is there really such a thing as a waste of time?

Who the fuck knows! Whatever! I have this badass tattoo of a skull riding a skateboard!

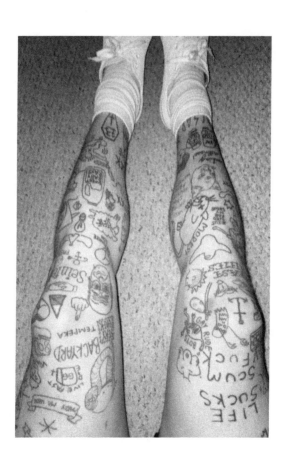

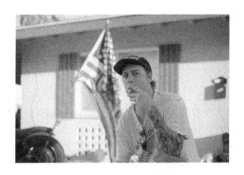

Tanner Ballengee is, amongst other things, a writer and artist, born and raised in Kansas, currently dwelling in Tempe, Arizona. He is a graduate of Washburn University and has been published by several independent literary journals. He has self-published a dozen or so zines in genres ranging from pornographic collage to poetry reconstructed from overheard conversations. Upon losing his job of three years, he chose to focus his newly found freedom on writing. This book is a product of his termination. More of his work can be found at tannerballengee.tumblr.com.

Other Fine Titles from Trident Press:

———

Blood-Soaked Buddha/Hard Earth Pascal
by Noah Cicero

"Far too many books about Buddhism get bogged down in scholarly doublespeak. Others are full of far-fetched fantasies. Noah's book isn't like that. It's a real book for real people.

Brad Warner, author of Hardcore Zen

it gets cold
by j.avery

it gets cold demands a body that is both the haunting and the house, a queerness that is both living and dying. What can be gained by inhabiting this liminal space? What can the inhabitation of dying bring to the living? What can be done when it gets cold?

Major Diamonds Nights & Knives
by Katie Foster

MDNK is a poetry project modeled after a deck of cards. While writing this poem, Katie Foster felt possessed by a spirit who died in childbirth. She tried to tell her story as best she could.

Cactus
by Nathaniel Kennon Perkins

In *Cactus*, correctional officer and ex-punk rocker Will Stephens works guarding prisoners who pick up trash on the side of the highway. One of them, a hardened inmate with a tattoo of the Black Flag logo right beneath his eye, seems oddly familiar, but Will can't quite place him.

The Pocket Peter Kropotkin

Collected in this cute, pocket-sized volume are eight of Kropotkin's essays. The book starts with his indispensable article on anarchism, originally written for the Eleventh Edition of the *Encyclopedia Britannica*, and moves forward to expound on his ideas, which include prison abolition, syndicalism, expropriation, etc.